COVENTRY LIBRARIES

Please return this book on or before
the last date stamped below.

CENTRAL LIBRARY

2 3 OCT 2004

1 6 MAR 2005

- 2 JUN 2018

Check Tag x

6A
27/2/23

D0574057

To renew this book take it to any of
the City Libraries before
the date due for return

Coventry City Council

Cover photographs:

front cover: Pilgrim badge of the bust of Thomas Becket, c.1320

back cover: Early seventeenth-century rosewater bowl by Richard Weir of Edinburgh, with Harvard House, High Street, Stratford-upon-Avon in the background where the Neish Collection of British Pewter is displayed.

AN INTRODUCTION TO BRITISH PEWTER

by
David Moulson and Alex Neish

illustrated from
THE NEISH COLLECTION
at the Museum of British Pewter
Harvard House, Stratford-upon-Avon

BREWIN BOOKS

First Published in October 1997 by
Brewin Books, Studley, Warwickshire
on behalf of

 The Shakespeare Birthplace Trust

Reprinted February 1999

ISBN: 1 85858 102 8

British Library Cataloguing-in-Publication Data

A catalogue record for this book is available from
the British Library.

Printed in Great Britain by Warwick Printing Company Limited,
Theatre Street, Warwick, Warwickshire CV34 4DR

David Moulson is a collector and dealer in pewter. He is a member of the committee of the Pewter Society and for many years edited its Newsletter. For several years he has been an adviser to the Shakespeare Birthplace Trust on the care and display of the pewter in its possession. With Andrew Holding he wrote *"Pewtering in Bewdley"* published in 1994.

Alex Neish, after studying law at Edinburgh University, moved to Buenos Aires in 1962. A passion for pewter brought him into contact with Richard Mundey, regarded by many as the doyen of British pewter dealers, with whom he developed a close friendship. Together they began an undeclared war to keep the best of British pewter in the United Kingdom. The Neish Collection is the result. It includes many outstanding items from Richard Mundey's lifelong, personal collection.

In 1996 Alex Neish gifted the collection to the Shakespeare Birthplace Trust so this important part of the British heritage could be kept together and placed on public display while he retired to Barcelona. He is a member of the Edinburgh Incorporation of Hammermen and a Freeman of the Worshipful Company of Pewterers.

CONTENTS

PREFACE

In 1592 William Shakespeare's father, John, who had lived in Henley Street for forty years, in the house now known as 'Shakespeare's Birthplace', lost two friends – Henry Field, a tanner, and Ralph Shaw, a near neighbour who, like himself, had been a wool dealer. Following their deaths John helped to draw up, for legal purposes, inventories of their belongings.

As John and his fellow assessors went through the rooms of Henry Field's house they noted down a range of pewter amongst the tanner's 'moveables', including: six dishes, eight platters, thirteen saucers, three porridge dishes, two chamberpots, four salt cellars, a wine pot and a dozen spoons. In Ralph Shaw's house there were over fifty pieces of pewter for everyday use to be recorded. These lists, and many others of a similar kind which survive, provide clear evidence of the prevalence of pewter in the households of Shakespeare's Stratford. The same could be said for any other town in England at the time.

In the year Henry Field died and had his pewter counted by John Shakespeare, his son Richard, now established as a printer in London, published William Shakespeare's first book, the narrative poem *Venus and Adonis.* (Perhaps the two young Stratfordians celebrated the event by quaffing ale poured in the familiar way from a pewter measure and drunk out of pewter pots). Around the same time, it seems, Shakespeare began work on *The Taming of the Shrew.* In the play one of the suitors of the desirable Bianca is the unsuitable, elderly Gremio, who presses his case with her father by citing his wealth, including his luxuriously-appointed house. After proudly listing several expensive furnishings which adorn his rooms, Gremio does not forget to add 'Pewter, and brass, and all things that belongs/ To house or housekeeping'.

As the authors of this book remind us, pewter belonged to house and housekeeping, at all levels of society, long before and after Shakespeare's time. For centuries it touched people in many areas of daily life: often when they drank, ate, relieved themselves, lit rooms, dipped their pens, accepted holy communion, played with toys, wore brooches, salted their dinner, and, in later periods, poured tea or coffee, took a pinch of snuff and stored cigars. All these uses are represented in the remarkable collection of British pewter gathered together over thirty-five years by Alex Neish. The collection comprises about eight hundred pieces, ranging from Roman times to the nineteenth century, and features items of great beauty and rarity, as well as hosts of more simple and common

pieces. This book's survey of the making and usage of pewter in Britain is accompanied throughout with illustrations of examples drawn from the Neish collection.

In 1996 Alex Neish, keen to see his collection kept together and given a permanent home in this country, generously donated it to the Shakespeare Birthplace Trust. The Trust cares for the five Shakespeare houses in or near Stratford-upon-Avon which are connected with the dramatist's family, and in addition has responsibility for a late-Elizabethan, timbered building in the centre of the town known as Harvard House, on account of its being the girlhood home of the mother of John Harvard, who helped to found the university that bears his name.

With Alex Neish's active support and the backing of, amongst the Worshipful Company of Pewterers, the Pewter Collectors' Club of America, the Pewter Society in Britain, the Dutch Pewter Society and individual collectors and enthusiasts around the world, it was decided by the Trust to create at Harvard House a Museum of British Pewter, based primarily on the Neish collection but not excluding other donations or loans. A principal aim of the Museum is educational: to create a wider public appreciation of the crucial part played by the silvery-grey metal in British social life over many centuries and to show how its enduring tradition continues today. This purpose is to be served partly by providing learning resources and by publishing literature relating to the collection.

This book, written by David Moulson, the pewter consultant to the Museum, in collaboration with Alex Neish, provides a helpful general introduction to the history of pewter in Britain, and I am sure those who read it will be affected by the enthusiasm of the authors for their subject. Through the illustrations it has the added value of sharing more widely one of the great pewter collections of our time, and hopefully it will induce many readers to visit Harvard House and see some of the pieces on display. By a happy coincidence, the building was for a while, in the late eighteenth century, used by ironmongers, who sold pewter to the locals. Perhaps amongst the worn pieces taken into the shop at this time for exchange were some of those listed by Shakespeare's father two centuries earlier.

Roger Pringle
Director of the Shakespeare Birthplace Trust

INTRODUCTION

The origins of pewter are lost in antiquity. The earliest known example of the metal to have survived is the flask-shaped, two-handled, lidded container found in an Egyptian grave at Abydos. Dated to between 1580 and 1350 B.C., its alloy comprises 93% tin, 6% lead, and 1% copper. Tin is always the major constituent of pewter. On its own the metal is relatively soft and difficult to cast, but the addition of small percentages of hardening agents like copper, lead, bismuth or antimony, overcomes this problem and adds durability.

It was only with the Romans, however, that pewter came into its own. In the first century A.D. Suetonius recorded silver vessels being removed from temples and replaced by others of pewter, a custom that was to appear centuries later in other countries. In Britain, the Roman conquest brought pewter into production. The raw materials were plentiful, with tin from Cornwall and lead from Wales and Derbyshire. Moulds were made from stone, with wood, clay and sand also being used.

When the Romans left Britain, the craft seems almost to have died out. It was probably revived by the Cistercian monks in the thirteenth century, and eventually the techniques were learned by lay people. By the end of the fifteenth century the craft was well established and pewter was to remain a basic commodity of life for the next four hundred years. All manner of items made today from glass, china, plastic, or stainless steel were once produced in pewter, such as jugs, plates, buttons, tankards, wine cups, inkwells, candlesticks and spoons.

In 1474, the London pewterers were granted a Royal Charter by King Edward IV giving them the legal control of the manufacture of pewter throughout England. They formed themselves into the Worshipful Company of Pewterers and had the power to regulate the quality of pewter being made and sold. 'Searchers' were sent out across the country to inspect pewter. Most market towns by the seventeenth and eighteenth centuries had at least one pewterer, and Stratford-upon-Avon was no exception. It was searched in 1676, 1690 and 1702 when a number of pewterers were working in the High Street and Chapel Street.[1]

These searches in England were carefully planned to take in as many as fifty pewterers and retailers on each of the two or three annual inspections. They checked the quality of the work and of the metal. An assay mould was dipped into the pewterer's melting pot, or a piece taken from a finished item, and the sample weighed against the standard pellets

carried by the searchers. Excess weight showed if too much lead – always significantly cheaper than tin – was being used. An Act of 1503 required all English pewterers to strike their maker's mark on their products to facilitate the identification of those responsible for sub-standard wares. Inferior merchandise was confiscated in what was one of the earliest examples of consumer protection. In Warwick this protection was extended in 1664 by Justices of the Peace who authorised one John Parshouse of Alcester, together with five other 'persons expert and skilful in the art and mystery of pewterers', to search throughout the county for pewterware 'not sufficiently wrought, mixed or marked'.[2]

The Worshipful Company saw its function as extending far beyond simple production standards. The searchers also had the duty to check the working conditions of apprentices and their behaviour (including their attendance at church on Sundays). They could impose fines and even corporal punishment. A similar attitude was adopted in Scotland and Ireland where the Company had no power. In Scotland the pewterers were one of the crafts grouped together in the incorporations of hammermen. Reflecting the size of Scotland and its poverty, there was an even greater emphasis on social responsibilities. In their care for the sick and for widows, the incorporations foreshadowed the social programmes that were to evolve in nineteenth-century Britain.

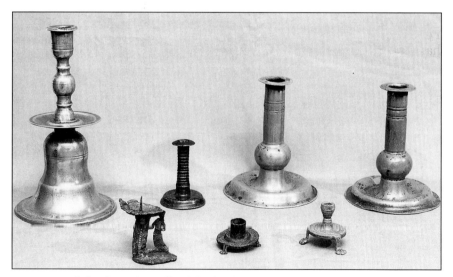

Selection of candlesticks from medieval times to c.1640

It was in the second half of the seventeenth century that the craft reached its heyday, employing over three thousand people. In London alone there were some four hundred pewterers' shops. Estimated production was around three thousand tons of finished product per year. It is thought that, amongst a population of only five million, some thirty thousand tons of pewter, equivalent to ninety million pieces, were in circulation, giving it a quasi-monopoly of the supply of domestic utensils. By the end of the eighteenth century, however, times had changed.[3] Pewter was facing severe competition from cheap, mass-produced crockery from places like Stoke-on-Trent, from the more durable copper and brass of Birmingham, and from Sheffield's silverplate. The industry responded with the development of Britannia Metal, a harder alloy of tin, antimony and copper, that could be rolled into thin sheets and then formed either in presses or by spinning. This cheapened production and allowed more decoration and even silver plating.

The advent of the Art Nouveau movement in the closing years of the nineteenth century stimulated new designs in pewter by people like Archibald Knox and Rex Silver, working for Liberty's of London whose wares were produced under the Tudric label by Haselers of Birmingham.

Today a modern pewtering industry still flourishes. Some manufacturers rely on traditional techniques. Others have introduced centrifugal casting with butyl rubber moulds to allow fine detail to be consistently reproduced. Many small firms exist dedicated to specialised items. A competition is organised each year by the Worshipful Company of Pewterers to stimulate young designers to use the metal that for so long has played a unique part in British domestic life.

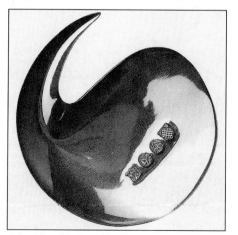

Letter-opener designed by Alan Pickersgill, 'Pewter Live' competition winner in 1992
(Reproduced courtesy of the Worshipful Company of Pewterers)

ROMANO-BRITISH PEWTER

What we now call pewter began in Britain with the Roman invasion, but when Julius Caesar made his initial raids in 54 and 53 A.D., it was a country peopled by warring tribes and only at the beginning of civilization. These conditions reduced the territory north of the Humber to an essentially military area, which remained that way during the whole period of Roman rule. To the south, however, was a province largely cleared for cultivation, drained, studded with villas and crossed by roads that forded the Avon and other rivers.

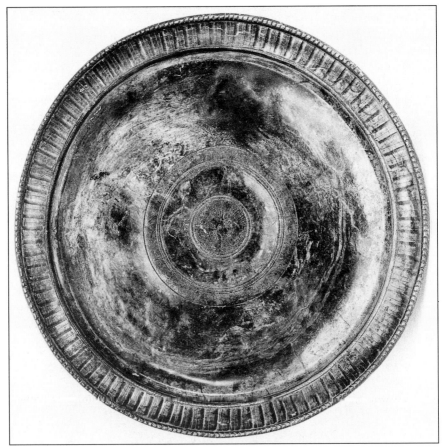

19³/₄ inch decorated Romano-British charger, possibly for ceremonial use

Cornish tin had been known in Europe before the invasion by Caesar, but there was no serious mining until around 250 A.D. The few surviving pieces of pewter prior to that period were made with tin imported from Spain. Once the Cornish mines had come into production, the availability of lead from the Mendip Hills combined with the presence of stable Roman settlements to trigger the development of pewter. Moulds and residual waste material have been found as far north as York and Manchester, and, of course, in Cornwall itself. The main finds of pewter, however, were in the areas of Bath and Appleshaw in the south-west of the country, and in the eastern area south of the fens and Northamptonshire. It was at Appleshaw, close to the intersection of two Roman roads in Hampshire, that the most

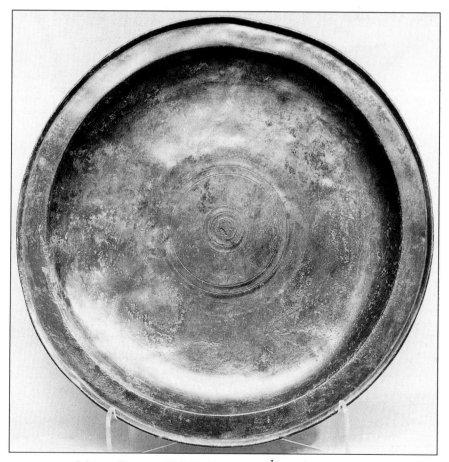

A large Romano-British charger, 17$^{1}/_{2}$ inches diameter

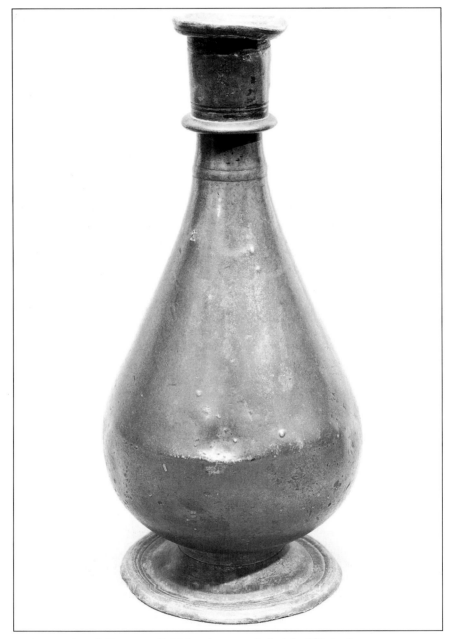

A Romano-British wine carafe, height 9$^{1}/_{2}$ inches

important cache to date was found in the late nineteenth century. Deliberately buried were ten circular dishes of varying sizes, a square $15^{1}/_{2}$ inch dish, an octagonal jug, bowls, saucers, a deep dish and a wine cup.

In total, however, less than four hundred Romano-British items have survived. The composition of their metal varies, as evidenced by an analysis of large plates which shows tin levels at around 75%, with flagons containing either around 50% or 90% tin.[4] Efforts to establish a type sequence have failed. None of this, however, is sufficient to obscure the existence of some outstanding craftsmanship. An octagonal flanged bowl with early Christian decoration and dating from the third or fourth century, now in the Ashmolean Museum, was described by one expert as 'perhaps the finest piece of pewter in the country.' Two examples of this type of bowl without the decoration are in the Neish Collection, which also includes an impressive dish of $19^{3}/_{4}$ inch diameter and $1^{1}/_{4}$ inch depth with a rim of indented design. In the centre of its well there is a raised circle with a finely decorated design. In its centre, in turn, is another circle with six beaded flanges that perhaps symbolise the sun. It may be that the plate was used in an important religious ceremony that was not Christian.

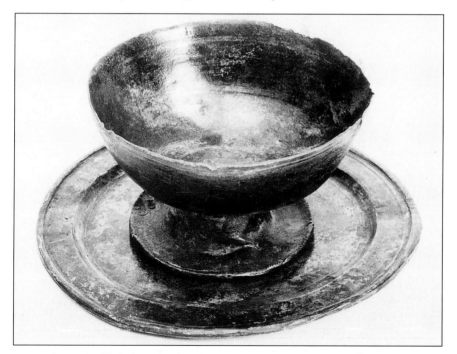

An early Christian chalice and paten, height of chalice $5^{1}/_{2}$ inches

PEWTER IN THE MEDIEVAL PERIOD

With the end of the Roman occupation in the fifth century, the manufacture of pewter appears to have become dormant except for some minor items of jewellery. It seems probable that the techniques were reintroduced in the twelfth or thirteenth century by the Cistercian monks who prided themselves on their self-sufficiency.[5] Their puritan philosophy did not allow the ostentation of gold and silver. Pewter, however, was permitted and they used it to supply themselves with ecclesiastical wares such as chalices, patens, spoons, and small candlesticks. For commercial

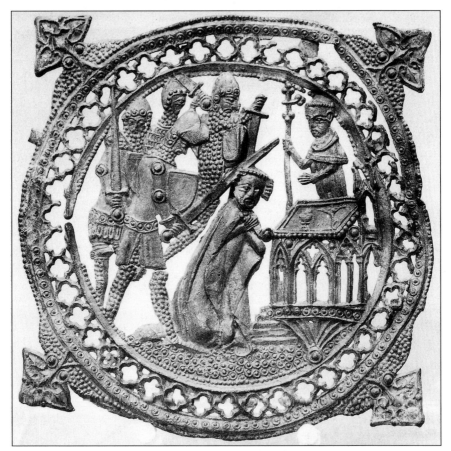

*Pilgrim badge showing the murder of Thomas Becket
in Canterbury Cathedral, 3³/₄ inches diameter*

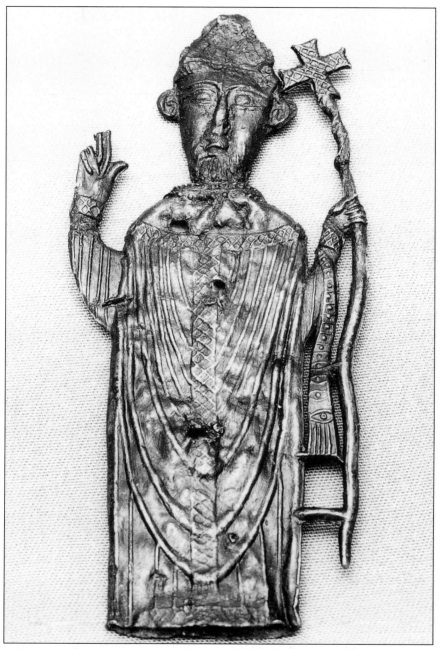

13th-century pilgrim staff head commemorating Thomas Becket, height 4 inches

purposes they produced pilgrim badges, some of which must number amongst the masterpieces of British pewter for their exquisite detail and decoration.

Reflecting increased activity, the production of Cornish tin rose by 50% in the early years of the thirteenth century. Inevitably the Cistercian expertise would have been learned by others outside the Order who went on to produce saucers, plates and spoons, with the first English domestic candlestick appearing around 1350. The expansion of the secular trade was so rapid that in 1348 ordinances to control the production of pewter were approved by the mayor and aldermen of London[6]. As in Scotland, this reflected the fact that the importance of pewter had been developing for some years, and finally was recognised with the implementation of rules for the craft. These determined that those entering the trade had to be

A fifteenth-century lover's token or badge, $1^3/_8$ inches diameter

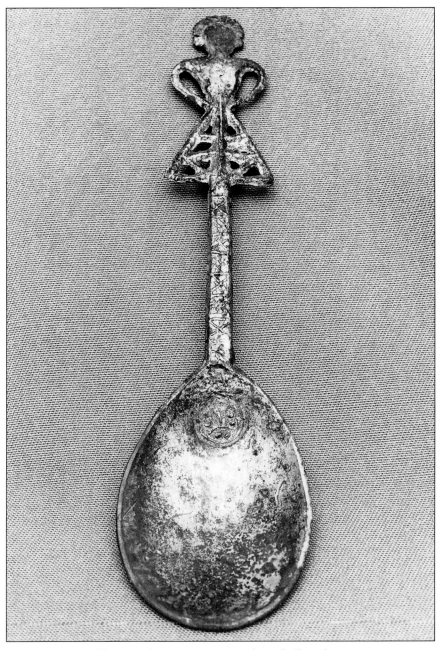

Rare early pewter spoon, length 5 inches

properly trained by serving an apprenticeship of seven years. They only became freemen, allowed to produce and sell their own pewter, once their expertise in the 'magic of pewter' had been approved. The goods produced had to be of a prescribed quality. In 1350 one John de Hiltone, 'peautrer', was brought before the mayor and aldermen of London and accused of making potel measures and salts that were 'made of false metal ... in deceit of the people, and to the disgrace of the whole trade'. He had used more lead than the sixteen pounds allowed to every hundredweight (112 lbs) of tin. This was a maximum limit and most

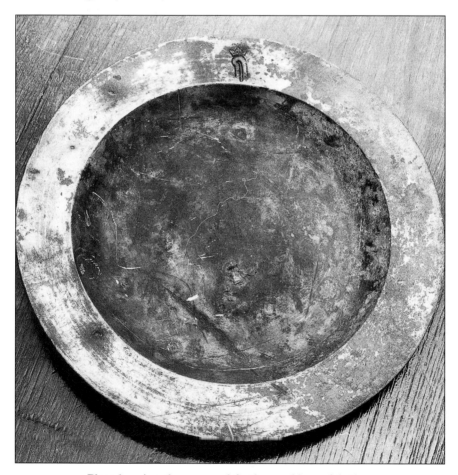

Plate bearing the crowned feather emblem of Arthur,
Prince of Wales, c.1500, $10^{1}/_{2}$ inches diameter

pewter from this and later periods used considerably less, marking it out from much pewter made on the Continent. In part the craft rules were allowed by the authorities because they protected the orderly existence of the trade. A further key element, however, was that they protected the public from shoddy goods.

As a result of the devastating Black Death of 1348, the medieval population of England fell from around four to two-and-a-half million. Significantly, this led to a period of relative prosperity for the survivors, and to a flourishing pewter industry whose goods began to permeate society. How widespread pewter had become was shown by the 1391 inventory of one Richard Toky, who was a grocer and not of the nobility. He owned two chargers, twelve platters, ten dishes, eleven saucers, nine trenchers, two half-gallon pots, three quart pots and one pint, salt-cellars, one candlestick, and one holy water stoup. The total weight was eighty-six pounds. These early items assimilated the designs of silver, wooden plates, leather drinking vessels and pottery. The pewterer was aiming to consolidate his trade by supplying goods to cater for every need. In 1348 a precept of the Mayor of London decreed that, to prevent fraud, all ale sold should be served in pewter pots stamped with their capacity.[7] The earliest known surviving measure is the hammerhead baluster in the Neish Collection that dates to c.1450.

In the sixteenth century it was normal, according to the Reverend William Harrison, for households to buy their requirements in garnishes of twelve platters, twelve dishes and twelve saucers. For the first time dressers were used for display. No garnish of the period has survived. A hoard of twenty plates ranging from ten to fourteen inches was, however, excavated on the site of Guy's Hospital in London in 1899. These are dated to c.1500 and bear on the rim a stamp of the ostrich feather that was the symbol of Prince Arthur, the Prince of Wales and eldest son of Henry VII.

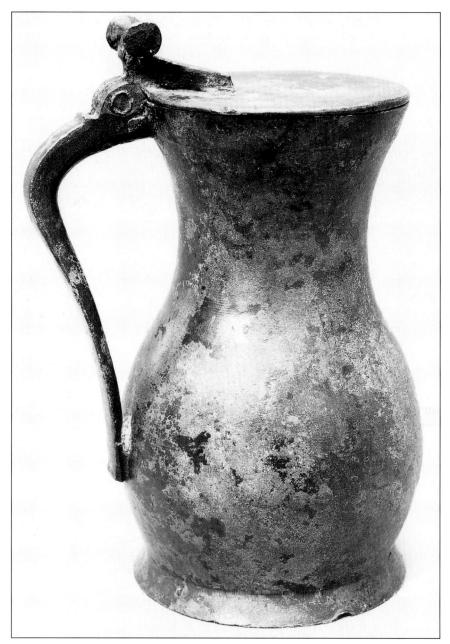

Baluster wine measure with hammerhead thumbpiece, c.1450, the earliest known example, height 7¹/₄ inches

THE SIXTEENTH CENTURY TO THE ENGLISH CIVIL WAR

This period witnessed a population explosion that compensated for the losses caused by the Black Death, with numbers increasing in the sixteenth and seventeenth centuries to between five and five and a half million. This was the motor that drove the expansion of the economy, and one craft to benefit was the pewterer's. Although growth was slower in Scotland and Ireland, inventories from the beginning of the period show that pewter was being used in at least half of English households. The items included the plates, spoons and measures of before, but now the range of spoons was vastly expanded as the porringer came into fashion for softer foods. Domestic candlesticks became more common and new drinking vessels appeared, even if their development was limited by competition from pottery, wood and stoneware.

Pewter recovered from the 'Mary Rose' warship that sank in 1545 has not only helped to date many items but also revealed other types that had not been known before, such as a screw-topped flask, a syringe and a wine flagon with a standing foot. Flagons were increasingly being used in the English Church, particularly after 1547 when the laity were again allowed to take communion. In 1603 it was ordered that sacramental wine be 'brought to the communion table in a clean and sweet standing pot or stoup of pewter,[8] if not of purer metal'. Many of these flagons have survived because of their value and the care with which they were treated.

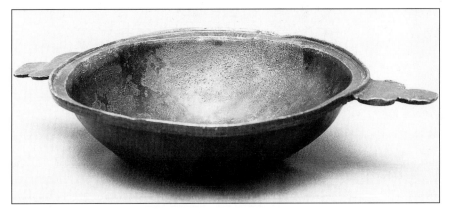

Porringer with two trefoil handles, early sixteenth century, 7¹/₂ inches diameter

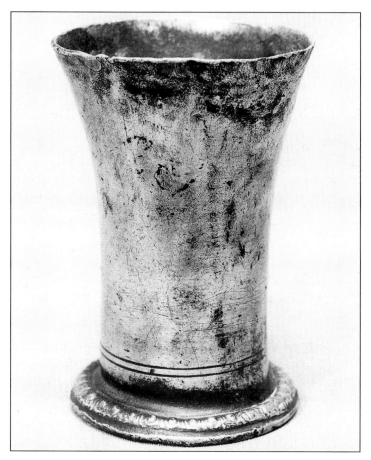

Flared wine beaker, late sixteenth century with cast decorated foot, height 3³/₄ inches

In the last twenty years of Queen Elizabeth's reign, inflation was increasing, in part because of the cost of wars. As rent and food prices rose, farmers and land owners seemed better off, and were able to buy richer furniture, and domestic utensils of silver, pewter and glass. In 1577 William Harrison, writing of times remembered by the eldest of his parishioners at Radwinter in Essex, noted 'three things marvellously altered'. These were the large increase in the number of chimneys, the improvement of furnish-ings, and the exchange of wooden platters and vessels for those of pewter.[9] Several references in Shakespeare's plays reflect the widespread use of pewter. In *The Taming of the Shrew,* for example, Gremio speaks of 'Pewter and brass and all things that belong to

house or housekeeping'. And Ben Jonson, in *Every Man in his Humour,* has Lorenzo senior say to Stefano, 'but for your luster only, which reflects as bright to the world as an old ale wife's pewter'.

In the early decades of the seventeenth century, unrest was provoked in England by the Crown's attitude towards religion. William Laud, the Archbishop of Canterbury and adviser to Charles I, was trying to move the Church back towards Rome. The economy had weakened, first under James I of England, and then Charles, as both tried to govern through corrupt favourites. Then came outbreaks of plague in the early 1620s and in 1640. The expense of government outran income and the King autocratically imposed new taxes. Ruling as an absolute monarch, he failed to summon Parliament for eleven years. Public dissat-

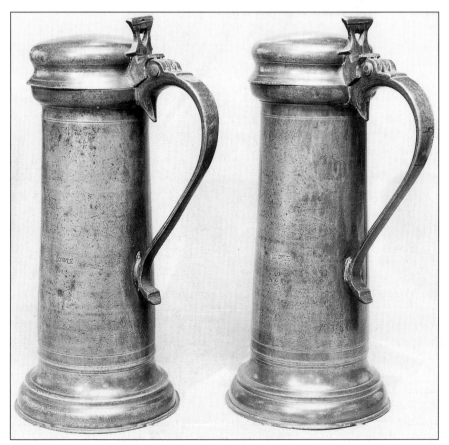

Pair of 'Charles I' flagons, c.1630, height to lip 11¹/4 inches

isfaction was mirrored by the constant struggle between parliamentary representation and royal divine right. This finally boiled over into the Civil War of 1642-47.

All of this stifled innovation and reduced economic demand. For pewter the position was made more serious by a sharp rise in tin prices between 1610 and 1650.[10] The scarcity of pewter that has survived from this period probably reflects the fact that less was being made – and that the rival forces roaming the country would have looted pewter, in part for the manufacture of ammunition. Around one hundred and fifty examples of the James I style of flagon have come down to us and a few hundred of the Charles I variety. These, along with small numbers of plates, dishes and spoons, are all that remain of English pewter production from these turbulent years.

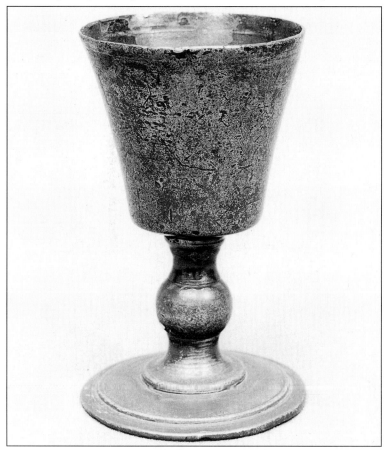

3 inch chalice or wine cup, mid-seventeenth century

THE GOLDEN PERIOD 1650–1700

The second half of the seventeenth century, with the restoration of the monarchy in 1660, saw conditions turning again in favour of the consumer. Real incomes rose as population growth declined, and the world of pewter saw a drop in tin prices of around 30% by the end of the century. This reflected the rise in English production from some seven hundred tons to over twelve hundred between 1660 and 1670. More tin was available from the mines of Bohemia while the Dutch were drawing on Malaya for supplies. There were new export markets in the West Indies, America, West Africa and the East Indies. Some two hundred and fifty tons were being exported by the end of the century.[11]

The restoration of the monarchy was celebrated with some of the greatest pieces of English pewter, notably large decorated chargers. More important, however, was the following explosion of design that marked

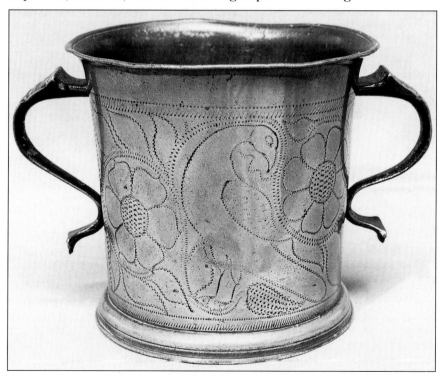

*Two handled toasting cup with fine wrigglework decoration, c.1660,
height 6 inches*

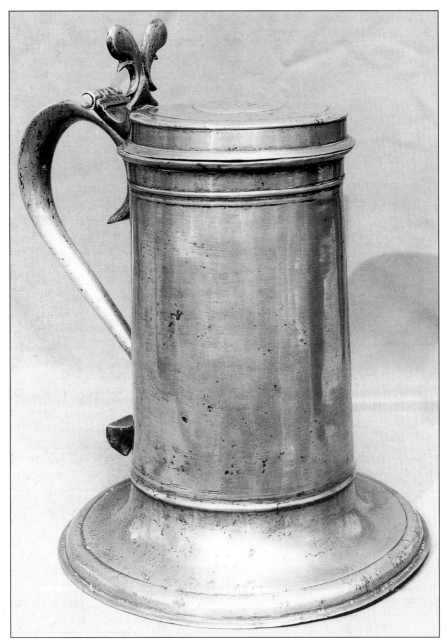

Large 'Beefeater' flagon 12 inches high with an exceptionally wide base, c.1670

this period as the golden age of British pewter. In part this was a reaction to the competition from delftwares, slipwares, glass and silver; in part it reflected the influences that came in from Holland with William and Mary; and in part it showed pewterers trying to stimulate demand by changing, for example, from broad rimmed plates to triple reeded ones. There was a move away from the elegant, plainer styles of the past towards an extravaganza of cast or wriggleworked decoration. This, however, was an enthusiasm limited to England. Ireland was left untouched and Scotland continued dourly with its traditional designs.

The English pewterers also benefited from the Great Fire of London in 1666, because many pieces of pewter were destroyed and had to be replaced. Another fillip came from the introduction into England by a French Protestant refugee, James Taudin, of Hard Metal, an alloy more

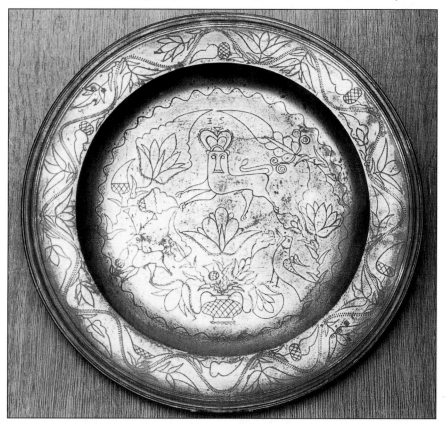

A triple-reeded dish decorated with tulips, acorns and a crowned lion,
18¹/₈ inches diameter by John Jackson of London c.1695

durable than previous ones. This again encouraged customers to change their plates and dishes.

The introduction of tea from China in the second half of the seventeenth century brought no benefit to the pewterers. This was a field destined to be dominated by the potter. English pewter tea pots are extremely rare until the emergence of those in Britannia Metal. On the other hand, the growth in beer and ale consumption led to a marked increase in pewter tavern pots. It

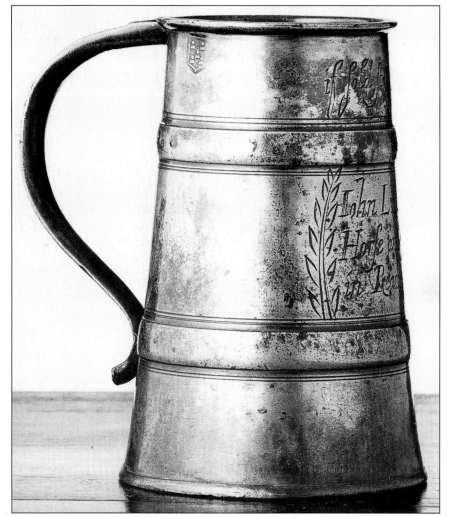

A two-banded drinking pot engraved "If Sold Stole", c.1699,
height 6³/4 inches

was the custom for wealthy customers to leave their pots at their favourite inn, and one celebrated example in the Neish Collection is engraved 'John Little at ye Horse and Jockey in Reading '99' and 'If Sold Stole'.

Towards the end of the seventeenth century the English pewter industry seems to have reached its peak. Between masters, journeymen, apprentices and servants, it gave employment to between two thousand five hundred and three thousand five hundred people. When Irish and Scottish pewterers were only getting into their stride, it had survived the earlier shortages of tin and, for the moment, had seen off the competition from alternative materials largely due to the improved designs. The pewter stock in England had probably reached its all-time peak.

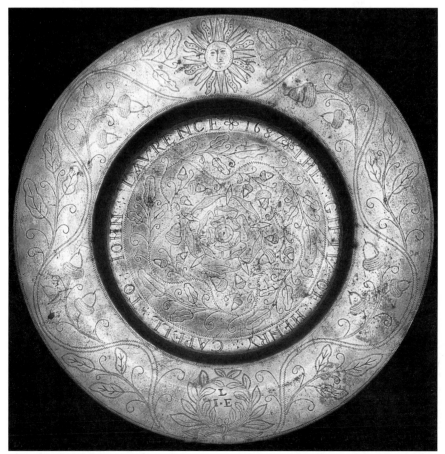

A large charger commemorating the restoration of the monarchy, engraved in wrigglework the symbols of oak branches, acorns and the sun. Engraved with later inscription, 22¹/₄ inches diameter

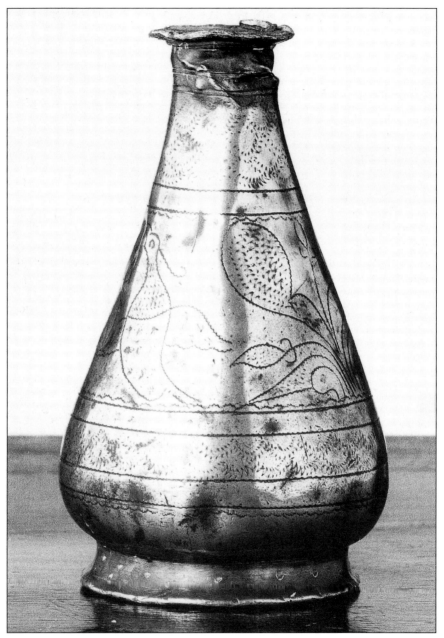

Wriggleworked small wine flask, c.1670, height 6 inches

THE EIGHTEENTH AND NINETEENTH CENTURIES

As the eighteenth century advanced, it is now clear that pewterware had set into a gradual decline. There were many reasons, one of the most significant being the preference for hot drinks, and in particular for tea. Tea imports into England and Wales had been around twenty six thousand pounds per year in the first decade of the century. By 1730 they had soared to one million pounds and climbed by a further million pounds in each of the next four decades.[12] When the import duty was substantially reduced in the late 1780s, consumption boomed to over twenty million pounds by the early nineteenth century. Over the same period beer consumption fell by over 50%, aggravated by a swing to hard liquor. This made a direct impact on the demand for pewter. The pewterers failed to exploit the new tea market. Throughout Britain they did attempt to introduce during the eighteenth century new designs and regional styles to develop a marketing edge. These, however, coincided with a steady increase in tin prices from the 1780s onwards. As the metal became ever more uncompetitive, the tide was visibly on the ebb.

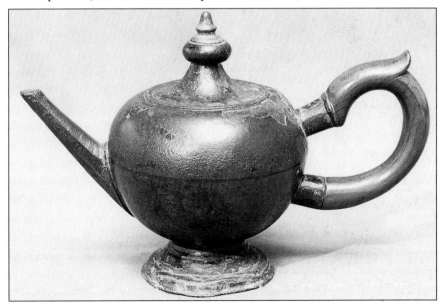

An early eighteenth-century 'cricket ball' teapot by Edward Quick of London c.1705, height 5 inches. This is the earliest known example.

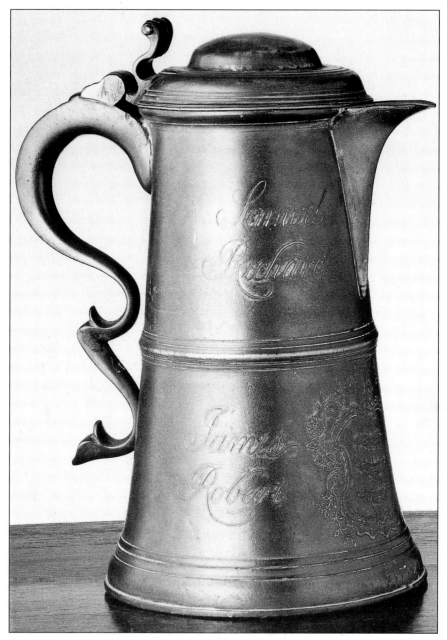

A large Norwich Friendly Society flagon dated 1770, height 13 inches

Some more innovative pewterers sought to bridge the gap by moving away from the traditional workshop techniques to a factory style production. One such was John Duncumb of Bewdley who, between the 1720s and 1740s, established one of the largest pewter businesses of the time. Instead of the jack-of-all-trades craftsmen, he employed twenty to thirty workers, each one of whom was a specialist at some part of the process, be it casting, turning or finishing, so that the production-line concept came into being. Under his name some twenty tons of finished pewterware was produced annually – the staggering equivalent of around fifty thousand nine-inch plates.[13]

During Duncumb's time it was the practice for pewterers to specialise in either flatware or hollow-ware and he was no exception. His

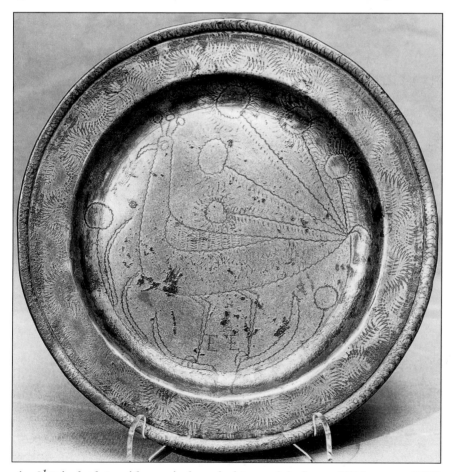

An 8¹/₂ inch plate with a wriggleworked peacock by James Hitchman, c.1720

sales records show large amounts of plates, dishes and basins but very little hollow-ware. Later on, successor businesses in Bewdley, like Ingram and Hunt, sought to compensate for a declining market by exploiting every kind of pewter article. The trend, however, was irretrievably downwards, even if this was temporarily disguised by the exploitation of two opportunities. The first was the introduction of the Imperial Measure in 1826. This meant that many measures previously used were now illegal, and so injected a huge demand into the market for the new capacities. The second was the 1830 Beer House Act which in one decade brought forty-five thousand new public houses into being, all of them requiring pots and measures. Some pewterers capitalised on the opportunity by supplying bar tops and pipes, and even beer engines.

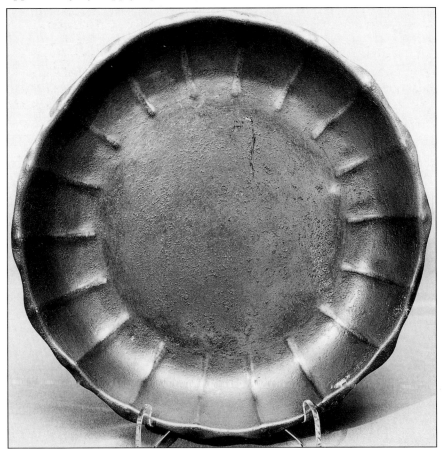

A mid-eighteenth-century strawberry dish, diameter 8⁷/₈ inches

As traditional cast pewter production continued its decline in the nineteenth century, another ship was launched. This was the Britannia Metal mentioned in the Introduction. It was developed first in Sheffield through firms such as Vickers and Dixon. Soon Birmingham was the home for around one hundred firms. Production was concentrated largely on tea and coffee pots made by spinning or pressing, but some cast items, such as plates, candlesticks and spoons were also made. Traditional pewter manufacturers were not averse to taking advantage of the new techniques. Thomas Alderson of London, when commissioned to make the pewterware for the Coronation banquet of George IV, may well have sub-contracted the sauce boats, probably to Sheffield.

For a time the new alloy halted the industry's decline for those who could adapt from the traditional casting process. By the end of the nineteenth century, however, the trade was represented in the main by the makers of beer mugs and measures, like James Yates of Birmingham. It was all summed up by Thomas Yates. In 1866 he wrote: 'Plates and dishes, which were at one time the staple production, are now made only in small quantities for a few foreign markets, and latterly the trade has been chiefly engaged in the manufacture of ale and wine measures, drinking cups, and other requisites for hotel purposes'.[14]

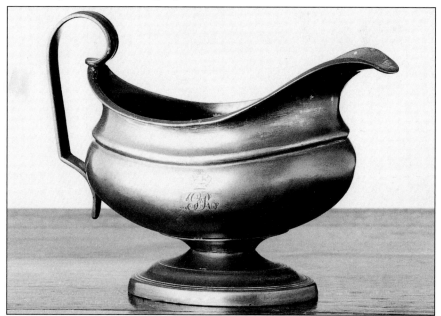

Britannia Metal sauce boat from the coronation banquet of George IV,
height 4³⁄4 inches

PEWTER IN THE TWENTIETH CENTURY

The new century saw a revival of interest in pewter wares, not as functional objects but as aesthetic ones. The man largely responsible was Arthur Lazenby Liberty, the founder of the Liberty and Co. department store in London. He believed, as did William Morris, in simplicity of design and fidelity to material. He described pewter as an 'essentially homely metal' and in 1904 castigated the French and German Art Nouveau creators for 'absurdly overdone decoration'. For Liberty 'the ideal of modern English pewter aims at more than a commercial success – it aims at a high standard in design, a high standard of workmanship, and a high standard in the quality of metal, and it strives to avoid over-modelling'.

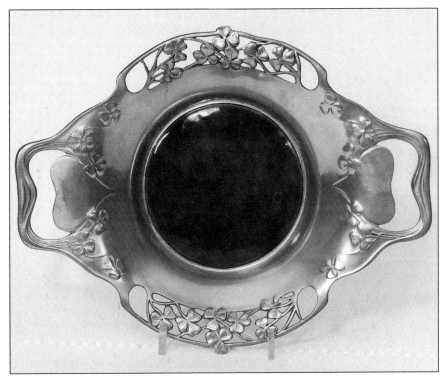

An enamelled pewter cake plate c.1902
(Reproduced courtesy of Jennifer Hornsby)

Liberty's principal designer was Archibald Knox who came from the Isle of Man with its long Celtic tradition. He based many of his designs on this tradition which had been preserved in the metalwork and literature of the Middle Ages. With Arthur Liberty he stimulated an awareness of pewter at a time when antique pewter was becoming more scarce. This in turn encouraged an increasing band of collectors to study the craft, to write books, and mount exhibitions. Some of these formed in 1918 what became known as the Pewter Society, which still exists today as one of the oldest societies of collectors.

The Art Nouveau fashion lasted from c.1895 to c.1910, though Liberty's continued to produce pewter up to 1938. Most of the later production was in the form of hammered tea and coffee sets. The Art Deco period failed to influence pewter design to any significant extent and pewter remained largely restricted to tankards and trophies.

The recent development of centrifugal casting of pewter has allowed volume production of small items with intricate designs aimed at the tourist market. This has led to another resurgence of the few pewtering businesses that are left in the United Kingdom.

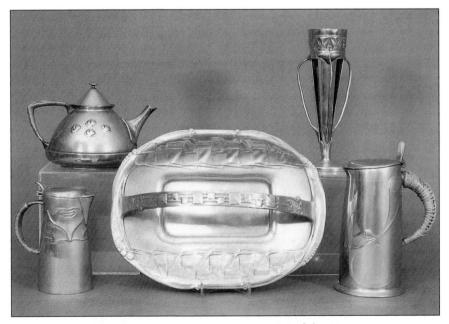

A range of Art Nouveau pewter produced for Liberty's
(Reproduced courtesy of Jennifer Hornsby)

For its part the Worshipful Company of Pewterers is encouraging modern designers to rediscover the attractions of the metal. An annual 'Pewter Live' competition is organised by the Company and has generated many exciting designs. In this way the craft that had its beginning in Britain nearly eighteen hundred years ago still flourishes and looks forward to a secure future. It will continue to satisfy the traditional market for domestic items and to offer high quality giftware to the tourist industry. In addition it will bring to an increasingly appreciative audience art-forms created from this beautiful metal.

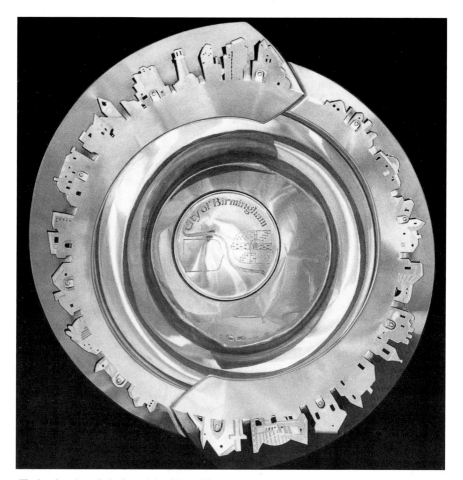

'Twinning bowl' designed by Chau Ling Ng, prize winner at 'Pewter Live' in 1995
(Reproduced courtesy of the Worshipful Company of Pewterers)

SCOTTISH PEWTER

The early history of pewter in Scotland is distinct from that in England. In 1430 the country's king was buying eight dozen pewter vessels from London, but by 1539 James V was importing workers from the Continent in an attempt to improve the quality of the craft. Probably the earliest pewterers worked at Dunfermline which at the time of the Battle of Hastings was already a royal residence with palace and abbey to attract dignitaries and craftsmen. When Edinburgh became the capital city, its craftsmen were granted their 'Seill of Cause' in 1483. A second followed in 1496 and specifically listed the 'peudrars'. Other incorporations including pewterers were to grow up at St. Andrew's, Dundee, Aberdeen, Elgin, Stirling and Glasgow. By the eighteenth century, pewterers were working in Inverness. Each incorporation sought to preserve the monopoly of its members against the inroads of gypsies, non-freemen and 'foreigners'. The remarkable similarity of their rules, however, must indicate an interchange like that of Elgin which sent to Perth for its hammermen regulations.

Before the seventeenth century, pewter in Scotland was a luxury item used by royalty and well-off burgesses. The most outstanding pieces are also the earliest dated examples of Scottish pewter. These are the two c.1600 rosewater dishes made by Richard Weir as part of a garnish for the Palace

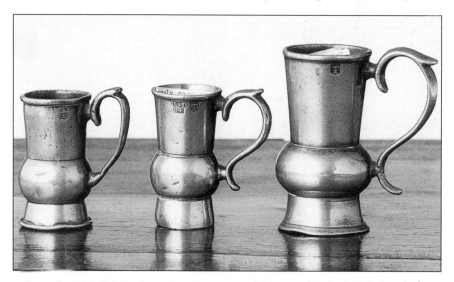

Rare Scottish thistle-shaped measures, c.1850, ranging in height from 2³⁄₈ inches to 3³⁄₈ inches high

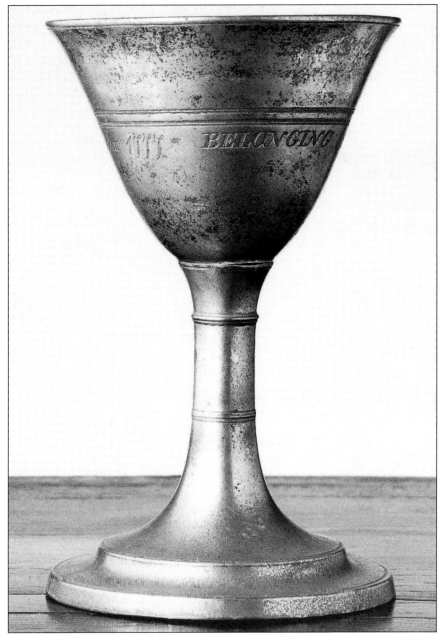

Scottish chalice with flared bowl, one of a set of four communion cups dated 1777, from the Associate Congregation of Sanquhar, $8^5/8$ inches high

of Holyrood, one of which is in the Neish Collection. With a diameter of $17^1/2$ inches, they carry in the base an enamelled boss with the royal arms of James VI and I, the deep well rising in a series of terraced levels.

The early pewterers faced the endemic poverty of the country and its almost impossible communications, to work in a metal for which the essential raw materials were lacking. Even in seventeenth-century Glasgow, small fleets of boats had to hazard the storms of northern Scotland before sailing for the Continent. In the eighteenth century travellers from London to Edinburgh preferred the relative comfort of sea-going vessels to being cooped up in a stage coach for a week.

Prior to the 1707 Act of Union, the hostilities with England down the centuries had made Holland and France the natural trading partners of

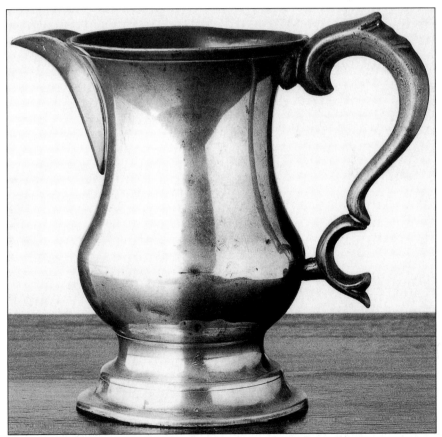

A quant measuring jug by Galbraith of Glasgow c.1800

Scotland. Dutch influence on design runs across the range of Scottish pewter, including its liquid capacities.

The dearth of raw materials saw much early Scottish pewter being re-cycled for new items. (In 1661 the price of pewter north of the border was practically double that in London.) On account of their cost, moulds were passed from father to son, and when only a widow survived she was allowed to continue to use her husband's moulds. Edinburgh offers several examples of this latter practice. Across the country there are other instances of incorporations buying the moulds of their deceased members as a form of financial support to the families. In the same way mort cloths were rented out to cover the coffins of members, surviving children automatically apprenticed, and pensions paid to the aged, creating one of the earliest social welfare schemes. The principal impact was that the forms of Scottish pewter tended to survive far longer than those in England. The French-inspired tappit hen measure, for example, ran from the late seventeenth century until well after the introduction of Imperial capacities in 1826.

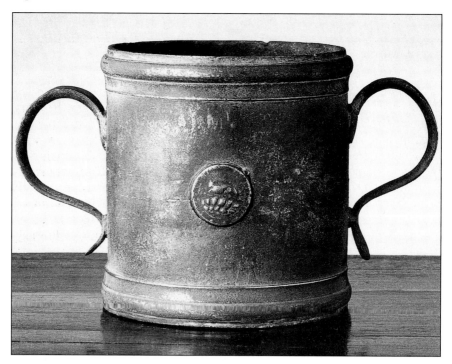

The Stirling standard grain measure c.1707, 7^{1}/$_{2}$ inches high

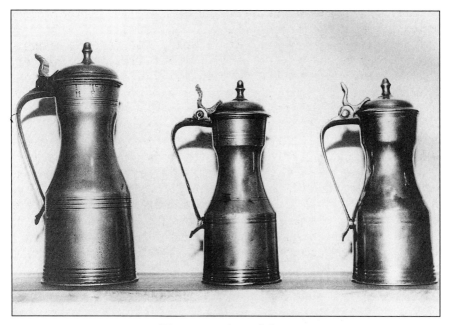

Three crested tappit hens

Another consequence was the resistance of the Scots to changes in liquid capacities. Despite the attempts of the Treaty of Union to unify standards with those of England, the Scots pint that contained triple the English measure was still being used in the nineteenth century with chopins and mutchkins, and the glass and bottle capacities. The confusion was made worse by the fact that Scottish measures had a 10% tolerance.

Following the Union, English styles of pewter began to appear north of the border even though the traditional Scottish pot-bellied measures and tappit hens were still being produced. The Scottish baluster appeared with features that made it quite distinctive from the English version. The communion flagon developed an English format into multiple alternatives to become uniquely Scottish. Totally original were the outstanding pear-shaped measures made in Scottish and English capacities by Glasgow's Galbraith family. Also uniquely Scottish were the thistle-shaped measures that were ordered to be destroyed, given their habit of retaining part of the contents in their accentuated bellies.

By 1800 the pewter craft in Scotland was moribund, undermined by cheaper alternatives. Practically no apprentices were being recruited, and

as the masters died out there were no replacements, although James Moyes of Edinburgh was still working in traditional formats up to 1880 and even making outmoded bottle capacities. He was, however, the end of the line.

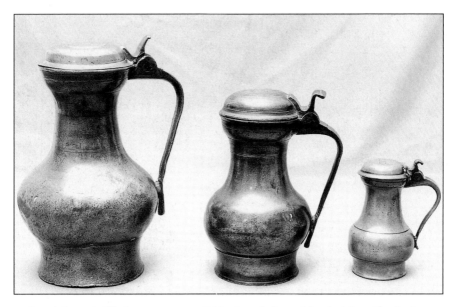

Scottish pot-bellied measures c.1700, from left to right; heights 8¹/₂ inches, 6¹/₂ inches and 4¹/₂ inches

IRISH PEWTER

Irish pewtering developed at around the same time as that in Scotland, the earliest known pewterer being John White who is recorded as working in Dublin in 1468.[15] The records from 1344 of the town's Holy Trinity Priory, however, detail the purchase of one dozen saucers of pewter or tin, a dozen dishes, a dozen plates of pewter, and two dozen chargers. Dublin Corporation archives of 1556 contain depositions on the import of 'foreign

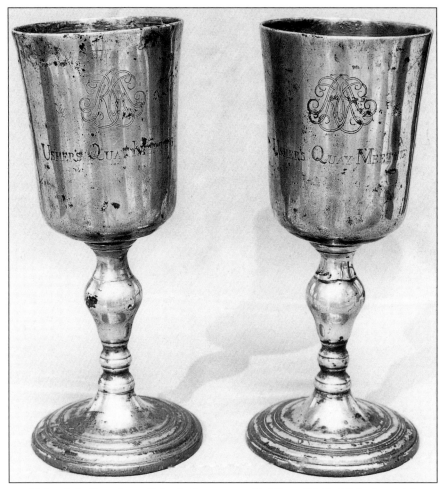

Pair of chalices from Usher's Quay near Dublin c.1740, 10 inches high

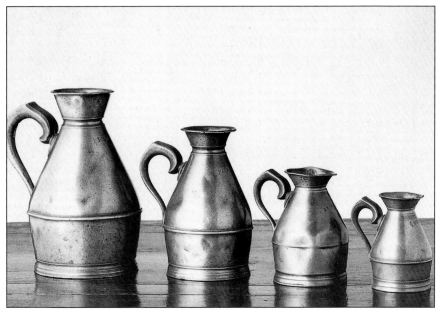

A range of Irish 'haystack' measures

An Irish loving cup with wriggleworked coat-of arms

pewter' showing that there was demand. In 1657 a Company of Hammermen was incorporated at Youghal and the pewterers were specifically mentioned as one of the crafts.

Irish pewterers experienced similar problems to their Scottish counterparts. The need to import tin from Cornwall, and lead from Wales, saw the earliest craftsmen establishing their businesses in the east port towns. Once again old pewter had to be recycled to keep down manufacturing costs, leading to a shortage of early items. The fact that the national economy was an agricultural one, based on exports of fish and hides, did not favour the development of a strong market for pewter. Only five craftsmen are documented prior to 1524. It was only as the economy strengthened that the number of pewterers increased to double figures after the first quarter of the seventeenth century, to reach its peak in the last third of the eighteenth century.

In this situation it is not surprising that no guild or company existed in Ireland formed exclusively by pewterers. The pewterer tended to be also a brazier, and he had to compete against the itinerant tinkers and hawkers whose standards were more lax. In 1697 and 1714 Acts of Parliament warned the public against 'counterfeit pewter and brass which is made and sold in Cork, Limerick, Birr, Waterford, Kilkenny, Galway, Loganclinbrasil and other places in this kingdom'. It was estimated that sales totalled a very significant £20,000 a year. Recent research identifies Dublin as the most important seventeenth-century centre of pewter production, with ninety-four pewterers working there out of a total of one hundred and six.[16] In the eighteenth-century, Cork was an important centre, with the Austen family pre-eminent.

Few pieces of Irish pewter dating from before the mid-eighteenth century survive. Those that do tend to be communion flagons with the coiled-spring type of handle, and bucket-shaped chalices. Both of these are very distinctive, as are two other Irish products. One comprises the nineteenth-century baluster measures that have neither handles nor lids and range from the half-pint down to the quarter-gill or noggin, this latter differing notably from the others. The other is the haystack measure that ranges from the gallon to the half-gill and is the most famous of all Irish pieces. It dates from around 1800 and is strongly associated with the Austen family.

WELSH PEWTER

It seems likely that pewter was used in Wales from early times and documentary sources show that pewtering was being carried out from at least the mid-sixteenth century. Pieces identifiable as Welsh, however, are extremely rare. Inventory evidence indicates that wealthy households in the Principality had owned considerable quantities of pewter. In 1665 Sir Edward Lloyd of Llanidloes owned 348 pounds of pewter. In 1735 the household known as Henblas on the island of Anglesey owned 114 plates, dishes and chargers. And in 1819 a jail in Montgomeryshire placed an order for twenty-four chamber pots. A number of nineteenth-century tavern measures have survived that bear Welsh verification stamps, while pewter is known to have been widely used in Welsh churches.[17]

The question is, where did all this pewter originate? Was there a Welsh pewtering industry? The available evidence must raise doubts. The order book of Ingram and Hunt in Bewdley shows they were supplying retailers throughout the Principality. Other records document imports through Welsh ports from Chester, Bristol and Barnstaple. Obviously the pewterers in other English border towns such as Worcester, Oswestry and Hereford would have supplied Welsh outlets. There is evidence that scrap pewter was being transported back into England from Wales. The deduction seemed to be that all pewter found in Wales was imported, but the recent discovery of a list of pewterers and braziers working in Haverfordwest from the mid-sixteenth to the seventeenth century led researchers to other towns.[18] They discovered Carmarthen had a Fraternity of Hammermen, including pewterers, as early as 1575. Its rules were recorded in the Council Order book of the Borough Corporation in 1633.

Further research identified Welsh towns that had pewterers who were either Welsh or had come from England. A list of some sixty pewterers spanning the period from the sixteenth to the nineteenth century was compiled. Obviously it is a small number for four hundred years and it explains why many apprentices had to be sent to Chester or Bristol for training with English Masters. The simple and inevitable conclusion is that pewtering was a marginal activity in a Wales that lacked prosperity and an urban infrastructure. Ireland showed a greater development. Scotland, with its continental contacts, its native royal family and its independence until the Treaty of Union, went its own way.

CHANNEL ISLANDS PEWTER

Originally part of France and today under British sovereignty, the Channel Islands of Jersey and Guernsey developed from around the beginning of the eighteenth century a style of flagon that was strongly influenced by the baluster type of the Normandy pichet. The Jersey variant is the earlier and is identified by a pronounced bulbous belly with a heart-shaped lid and acorn thumb-piece. (The islanders believed the acorn thumb-piece warded off thunderbolts.) The flagons were not for wine but for cider. Wine imports were actually prohibited to defend the cider apple orchards that in the eighteenth century covered one quarter of Jersey and produced an estimated one and a half million gallons of the beverage.[19]

In 1688 two French Huguenot refugees fled to the island, giving as their profession 'potier d'etain' or pewterer. Whether they invented the style of the Jersey flagon is unknown. One Pierre du Rousseau, however, was the maker of a handful of early flagons that have survived, and this would strongly suggest island production. The later variant from Guernsey was normally made by English pewterers. There is speculation that one or more may have been Channel Island residents who moved to the English mainland.

Jersey flagon, eighteenth century, height 7 inches

PEWTERERS OF STRATFORD-UPON-AVON

The records of the Worshipful Company of Pewterers and their Searchers reveal the existence of pewterers working in Stratford-upon-Avon. In 1676, and again in 1690, one William Baker of 20 Chapel Street was 'searched'. In a deed he is described as a brazier, this being a common term for a craftsman who worked in brass, pewter and perhaps tinware. Baker was clearly a successful man; in 1693 he was an Alderman and three years later he subscribed to repairing the Clopton Bridge. In 1697 he paid a poor rate of £9, and his inventory lists:

> In the shop brass and pewter and tinware £120
>
> In the cellar a parcel of old brass and wire working tools £15
>
> In a shop at Henley brass and pewter £20
>
> In a shop at Knighton brass and pewter £20

John Perks was searched at Henley in 1676 but in 1677 he was recorded as being a brazier at 11-13 High Street, Stratford. In 1689 he owed a Worcester pewterer, Sampson Bourne the second, the sum of £28 16s 0d for pewter, showing that like many others he made some items himself and bought stock from other pewterers. In 1702 at the same address Richard Perks was searched, having presumably taken over the business of his father. John Scrivens worked at 16 High Street from 1698 to 1716 and was searched in 1702. Thomas Badger worked at 6 High Street and was also searched in 1702. His will, dated 20 September 1742, bequeathed to his wife, Elizabeth, his 'messuages' and lands in Stratford and Shottery, and all his personal estate.

That pewtering was an important business in the Stratford of the late seventeenth and early eighteenth century may be seen from the fact that all of these pewterers occupied prime retailing sites in the centre of the town, and died wealthy men.

MANUFACTURING METHODS

There were three original standards of the pewter alloy established by the Worshipful Company of Pewterers in England.[20] In Scotland and Ireland no specific regulations appear to have existed. The top quality applied to flatware (sometimes called 'sadware'), the generic term that embraced plates, dishes and basins. Its manufacture required the use of 95% tin alloyed with small amounts of copper and/or lead. Hollow-ware allowed the use of up to 16% lead. The lowest quality, called 'trifle', was authorised for candlesticks, toys and small pieces. By allowing the use of old pewter it was subject to wider variations.

These quantities evolved with time. From the late sixteenth century around three pounds of bismuth were being added to every thousand pounds of tin for greater durability. In the early 1650s the Frenchman James Taudin introduced to London his 'Fine White Metal call'd French Pewter'. In various actions against him by the Company, Taudin attracted the support first of Cromwell and then of Charles II. In the nineteenth century tin was alloyed with antimony and 2% copper to produce the form of pewter called Britannia Metal.

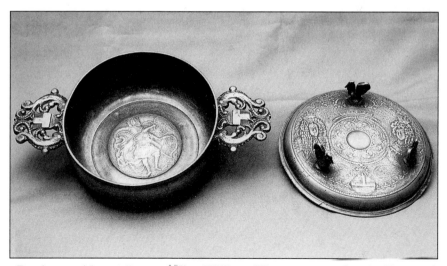

Porringer with cast figure of King William III commemorating the Treaty of Ryswick in 1697, bowl 5 inches diameter. The lid with portraits of William and Mary

Casting and Finishing

The traditional method of making pewter consisted of pouring the molten metal into a mould. Archaeological research shows that the Romans used limestone moulds. By the medieval period soapstone and cuttlefish bones were also used for making moulds for pilgrim badges and other small items. Increasingly, however, bronze came to pre-eminence on account of its durability and the qualities of heat transference that allowed the metal to cool and harden quickly, so accelerating production.

Flatware could be produced from a two-part mould that had been coated with red ochre and egg white to facilitate the removal of the casting. Burrs and flashing were filed off before the piece was mounted on a lathe to be turned, front and back. Often small pin stock marks may be seen in the centre of dishes and chargers. The curved area between the rim and the well, called the 'booge', was then beaten with a hammer to harden the metal and make it more resistant to splitting. The hammer marks on sixteenth-century dishes and plates found on the wreck of the 'Mary Rose' are very large, roughly $^3/_4$ by $^1/_2$ inches. In later centuries smaller hammers came into use. Polishing was then done while the lathe was turning, or on a bench, often using Mare's Tail, an abrasive plant with silicate deposits, or sometimes fine sand from the River Trent, or 'Tripoli', a form of decayed

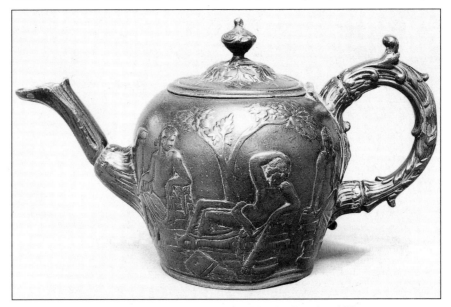

Cast-decorated teapot inspired by the Portland Vase

limestone imported from North Africa.[21] When this process was completed, the maker's marks would be struck using steel punches.

The manufacture of hollow-ware was more complicated. A lidded vessel might require five moulds to create the top and bottom body sections, the lid, the thumb-piece and the handle. The latter was soldered on, as was the thumb-piece. The lid would be secured to the hinge lug on the handle by a brass or pewter pin, and then the whole piece polished, and the maker's mark struck.

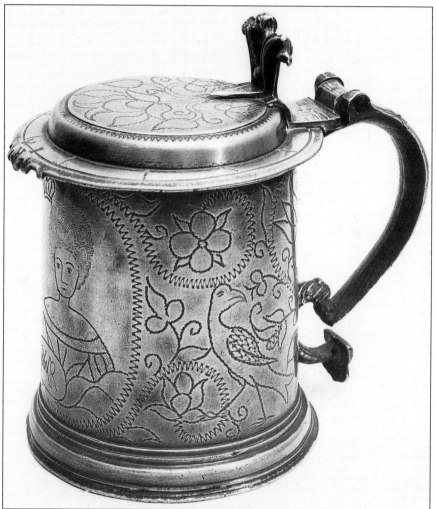

Wriggleworked tankard with portraits of William and Mary c.1690, height 4³/4 inches with the crowned touch of 'R.S.'

The Decoration of Pewter

In eighteenth-century Holland much pewter was japanned, and in nineteenth-century Germany some pewter was painted with enamel. No examples of this work, or of Continental cut-out fretting are known in British pewter. A variety of techniques were, however, used to decorate the metal.

Most famous is wrigglework, a form of engraving where shapes are drawn in a zig-zag line using a tool like a screwdriver. Known on excavated fragments from as early as c.1200, it became fashionable in England from around 1680, though a pair of candlesticks from around 1650 shows this decoration. Favourite themes were birds, animals and flowers. No examples exist in Scotland except on pieces that are really Dutch. Rare and

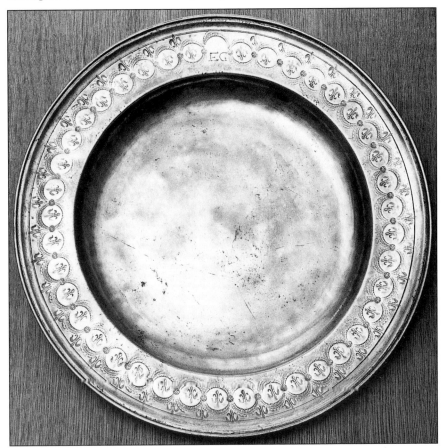

Seventeenth-century charger with punched decoration, diameter 18¹/₈ inches

highly prized are the royal portrait tankards of William and Mary of which several outstanding examples exist in the Neish Collection.

In cast decoration, which was common on pilgrim badges, the decoration is cut into the mould itself. This technique was used in a number of late seventeenth-century porringers. The later line engraving saw plain lines being made with sharp chisels.

Punched decoration is very rare. It involved the use of one or more punches used repetitively, usually round the edge of a dish. An unusual combination of wriggled work and punched decoration appears on a c.1700 plate by Thomas Leach in the Neish Collection.

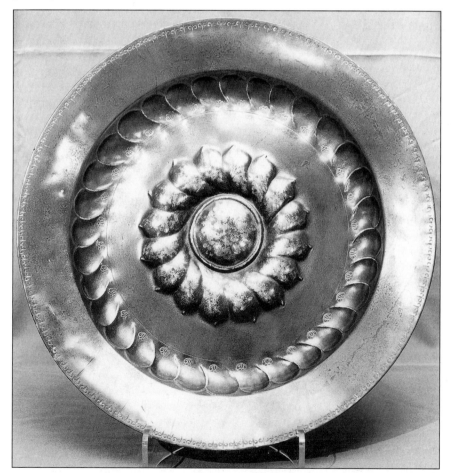

Dish decorated with repoussé work and punched decoration, c.1750,
13$^1/_2$ inches diameter

Fine examples of designs cut into the metal can be found on English colanders and straining dishes. Most of these dishes have long been separated from the garnishes with which they were used to allow liquid to drain off from the meat or fish.

Enamelled bosses with coats of arms appear on dishes in both England and Scotland, almost all of them having royal connections. Fakes of these important pieces are known to exist.

Repoussé work involved the hammering of three-dimensional shapes into the metal. English examples date from the beginning of the eighteenth century and the art was revived using old dishes at the end of the nineteenth century. Towards the end of the eighteenth century the invention of the rose-engine, an appendage to a turning lathe, allowed complex patterns to be engraved onto plates.

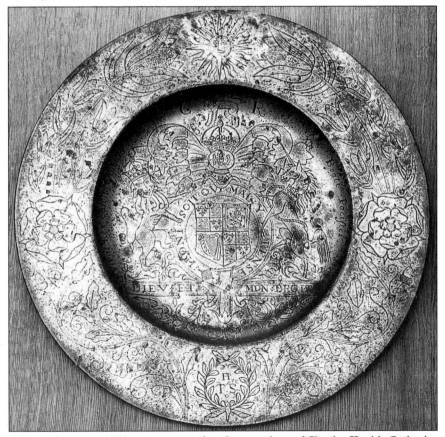

A large charger c.1662 commemorating the marriage of Charles II with Catherine of Braganza, engraved with wrigglework decoration, 21³/4 inches diameter

HOW PEWTER WAS SOLD

Pewter prices rose with the increase in demand during the sixteenth and seventeenth centuries. Sold by weight, it had cost $4^{1}/_{4}$d a pound around 1500, but rose to 9d a pound by 1600. Immediately after the Civil War it peaked at 1s 2d, declining to around 11d a pound by 1700.[22] Time distorts the monetary values. To put them in context, a set of twelve plates would have cost around 9s 8d in 1680, the equivalent of ten days' wages for a skilled craftsman, or about twenty days for a labourer.

One way of reducing the cost of new pewter was to trade in old, damaged, or unfashionable pieces. In 1500 this could represent half the cost of new pewter, but by 1680 it had risen to around three quarters.[23] This is one of the reasons for the scarcity of pre-1700 pewter. Another was the lack of durability that limited the useful life of a plate to around ten years. Yet another was the practice of melting it down for musket balls in times of war.

The increasing value of the metal, coupled with the growing diversity of items, made the holding of stock a problem for the smaller pewterer. Many would have bought in products from larger pewterers in the area. Some of these goods were only part-finished, and would be completed by the second pewterer before being sold. The seventeenth-century pewterer's shop would have been a hot and noisy place of production and it was only later that some attempt was made to introduce the 'customer-friendly' concept of production being at the rear of the property and the retail operation at the front. However, the 80% of the population that lived in the country would have tended to buy their pewter at fairs and markets or from local craftsmen.

Other suppliers of pewter were the itinerant traders known as chapmen, hawkers or pedlars, who carried their stock with them and sold their wares around the streets or at fairs. Mistrusted by both customers and suppliers, they reduced the demand for new pewter by repairing the old, and by trading in second-hand pewter. It was suspected they made false representations on the quality of their offerings. As early as 1566 a Court of the Pewterers' Company licensed three Maidstone individuals 'for the disabolishing all hawkers for any manner of metal within Kent and Sussex'.[24] In 1591 the Guild bribed John Backhouse to give up hawking by giving him 5 shillings to buy tools and set up as a pewterer. In Scotland, however, the tinker or 'tinkler' enjoyed a different status. He was equally an itinerant tin-smith and pedlar, but in both the Stirling and Perth Incorporations of Hammermen he was an accepted member.

When pewter was being transported any distance, it would have travelled by pack-horse, wagon or boat. In eighteenth-century Bewdley pewter was shipped up and down the river Severn to Shrewsbury, Gloucester and Bristol. Long lines of pack-horses were used to deliver pewter to customers westwards in the Welsh Marches and east to the Midlands. By the end of the eighteenth century Ingram and Hunt of Bewdley were recording in their account books customers spread over most of England and Wales. As part of this early mass marketing, they employed a Mr. Stinton as their representative. It was his job to travel the country, seeking orders from major wholesalers and from retail shops in the towns. Harvard House itself was used by ironmongers between 1782 and 1801 and pewter would have been sold there.

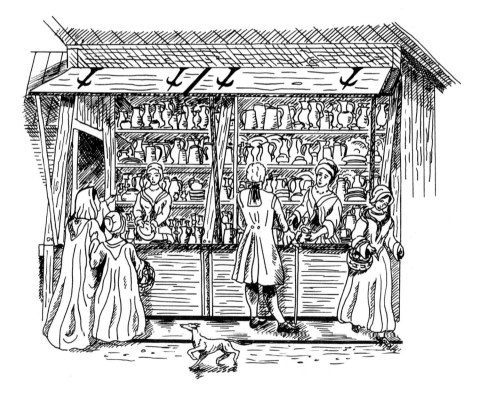

An eighteenth-century pewterer's shop, after Christopher Kilian
(Reproduced courtesy of Jane Moulson)

MARKS TO BE FOUND ON PEWTER

Touchmarks

When a pewterer had completed his seven-year apprenticeship, he would submit an example of his work to the guild for approval and thereafter, assuming objections were not lodged, would register and, if in England, 'strike' his touchmark which was unique to himself.

TOUCHMARK –
Actual height 1.7cm

In Ireland there was no governing body and most pewterers worked without striking a touchmark. In Scotland each incorporation of hammermen laid down the work to be submitted by apprentices applying to become freemen. Some required the pewterer to strike his mark, others did not. A further complication is that some touchmarks were used by father, son and grandson, with minor or no variations.

Hallmarks

In the seventeenth century, perhaps as a marketing ploy, it became common for pewterers to stamp their work with a set of marks, usually four in number, emulating those found on silver. Unlike the latter, however, they include neither a town mark nor a date letter, but they do serve to identify the individual pewterer.

HALLMARKS – Actual heights 0.5cm

Rose and Crown

From the middle of the sixteenth century, this mark, taken from the Tudor rose of England, was used to denote quality and its use in England was controlled by the Worshipful Company. Most pewterers had their own variations on the design, which was also used in Holland by pewterers imitating the English quality emblem.

ROSE AND CROWN –
actual height 1.7cm

Crowned 'X'

This, like the Rose and Crown, was originally an English quality mark. By the eighteenth century, however, control over it had been lost and its use was widely abused by craftsmen seeking to promote their pewter.

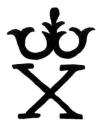

CROWNED X –
actual height 0.8cm

Hammer and Crowned Hammer

Usually struck on the rim of a plate, this mark is believed to have denoted high quality and was used from the early fourteenth century for around two hundred years.

HAMMER MARK –
actual height 1.5cm

Labels or Cartouches

Traditionally the pewter of London was considered to be superior. As a result, provincial pewterers in England began to stamp 'London' on their pieces, as indeed did several continental craftsmen. Naturally the genuine London pewterers objected, and some began to include their London address. Other advertising slogans were incorporated into these labels, such as 'Superfine Hard Metal', to promote the idea that the goods were of a superior quality. A similar system developed on the continent.

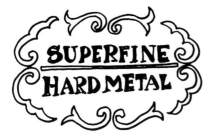

actual size 2.5cm x 1.2cm

actual size 1.8cm x 1.0cm

Verification Marks

These are the stamps found on pewter (and measures in other materials) to indicate that the capacity had been certified by local inspectors as conforming to correct standards. An ordinance passed by Edward I (1272-1307) decreed that 'no measure shall be in any town unless it do agree with the King's measure, and marked with the seal of the shire town'.[25] This was another early step to protect consumers from unscrupulous tradesmen. Later, local authorities had to appoint inspectors and each was allocated a district with a specific registration number. These marks show where a measure was

VERIFICATION MARK –
actual size
1.0cm x 0.8cm

used, and may help determine, in the absence of a maker's mark, where it might have been made. In Scotland it is common to find the letters 'DG' which signify the approval of the Dean of the Guild and help to date pieces.

COLLECTING PEWTER

The question 'What to Collect?' has many answers. The simplest is 'Collect what you like, what gives you pleasure'. Some will specialise in specific areas or makers, others in special styles or periods. Along the way mistakes will be made. But if a piece gives pleasure, the pain of discovering it is in fact a modern reproduction, possibly with faked touchmarks seeking to deceive the unwary, will be considerably reduced. Mistakes are part of the learning process. That is a good reason for beginning modestly at antiques fairs or unpretentious shops, particularly in country areas. It is extremely unlikely anything will be found more than a couple of centuries old, but the prices should be reasonable. The new collector can get the feel of the metal, learn to identify verification marks and touches, separate out pewter from the later and lighter Britannia metal. He will begin to appreciate signs of wear and use, note knife marks across the front of plates, detect the difference between touchmarks that have been rubbed by years of usage and those that are indistinct because they were badly struck to simulate wear.

At the level of expensive pieces, the best advice to the new collector is to consult a professional dealer, one who lives by the profits of his pewter business and is jealous to defend his business reputation. This maxim will at one swoop eliminate the dealers who specialise in other fields and only dabble in pewter because the odd bit comes their way and a quick profit appeals. The collector who buys because he thinks he is getting a bargain has only himself to blame if the piece is revealed as false. The problem, however, is that the number of professional dealers today may be counted on one hand. The collector can flirt with all of them, but will be loved by none. This may lead to a coveted piece being lost to a more faithful collector.

As a final dictum to the serious collector, there is a piece of advice given years ago by Richard Mundey, the notable twentieth-century dealer in antique British pewter. It is simply 'Buy the best you can afford. That way you will never have any justifiable regrets.'

With his collection begun – because, as Alex Neish says, 'a pewter collection never ends' – the next piece of knowledge the collector requires is how to care for each piece. For most items it will be enough to wash with a mild detergent, and then rub with a soft cloth and a non-abrasive metal cleaner. When, due to neglect, the metal has developed a dark surface corrosion of scale, or the eruptions known as 'pewter cancer', it is best again to consult a professional expert. In some cases electrolytic cleaning may be required. The metal has a low melting point and can easily be damaged. Just as one would consult the best surgeon one can find for a major operation, so for fine and rare pewter one should do the same.

REFERENCES

1. Homer, R.F. and Hall, D.W. *Provincial Pewterers,* 60.
2. Moulson, D., Journal of the Pewter Society, Vol. 4, 37.
3. Hull, C., *Pewter,* Shire Album.
4. Beagrie, N., *Britannia,* Vol. XX, 1989.
5. Hooper, P., Journal of the Pewter Society, Vol. 8, 132.
6. Hatcher, J. and Barker, T.C., *A History of British Pewter,* 145.
7. Herbert, *The 12 Great Livery Companies,* Vol. 1, 58.
8. Massé, H.J.L.J., *Pewter Plate,* 93.
9. Harrison, W., *The Description of England.* ed G. Edelen, 1968.
10. Hatcher and Barker, Appendix B, Table 15.
11. Hatcher and Barker, 138.
12. Hatcher and Barker, 281.
13. Homer and Hall, 64.
14. Yates, T., *'Pewter and Britannia Metal Trade': Birmingham and the Midland Hardware District,* edited S. Timmins.
15. Hall, D., *Irish Pewter,* 40.
16. Hall, 42.
17. Homer and Hall, 121.
18. Homer and Hall, 123.
19. Woolmer, S. and Arkwright, C., *Pewter of the Channel Islands,* 16.
20. Hatcher and Barker, 223.
21. Holding, A. and Moulson, D., *Pewtering in Bewdley,* 2.
22. Hatcher and Barker, 276.
23. Hornsby, P., Journal of the Pewter Society, Vol. 3, 10.
24. Welch, C., *History of the Worshipful Company of Pewterers,* 254.
25. Ricketts, C., *Marks and Marking of Weights and Measure,* v.

USEFUL CONTACTS

1. The Pewter Society. Honorary Secretary: c/o The Shakespeare Birthplace Trust, The Shakespeare Centre, Henley Street, Stratford-upon-Avon, CV37 6QW, telephone: 01789 204016.
2. The Worshipful Company of Pewterers, Pewterers' Hall, Oat Lane, London, EC2V 7DE, telephone: 0171 606 9363.
3. Adviser to the Museum of British Pewter, Mr. David Moulson, c/o The Shakespeare Birthplace Trust, The Shakespeare Centre, Henley Street, Stratford-upon-Avon, CV37 6QW, telephone: 01789 204016.

FURTHER READING

Brett, V., *Phaidon Guide to Pewter,* Phaidon 1981.
Cotterell, H.H., *Old Pewter – Its Makers and Marks,* Batsford 1929.
Gordon, K., *Pewter – The Candlestick Maker's Bawle,* published by author 1994.
Hall, D.W., *Irish Pewter,* The Pewter Society 1995.
Hatcher, J., and Barker, T.C., *A History of British Pewter,* Longman 1974.
Homer, R.F. and Hall, D.W., *Provincial Pewterers,* Phillimore 1985.
Hornsby, P., *Pewter, Copper & Brass,* Hamlyn 1981.
Hornsby, P., *Pewter of the Western World,* Schiffer 1983.
Hornsby, P., Weinstein, R. and Homer, R., *Pewter, a Celebration of the Craft, 1200-1700, Museum of London 1990.*
Hull, C., *Pewter,* Shire Album 1992.
Massé, H.J.L.J. (revised Michaelis R.F.), *The Pewter Collector,* Barrie & Jenkins 1971.
Moulson, D.S. and Holding, A. *Pewtering in Bewdley,* Wyre Forest District Council 1994.
Peal, C.A., *British Pewter and Britannia Metal,* John Gifford 1971.
Ricketts, C., *Marks and Marking of Weights and Measures of the British Isles,* Ricketts 1996.
Scott, J., *Pewter Wares from Sheffield,* Antiques Press 1980.
Welch, C., *History of the Worshipful Company of Pewterers,* Blades, East and Blades 1902.
Wood, L. Ingleby, *Scottish Pewterware and Pewterers,* Morton 1907.
Woolmer, S. and Arkwright, C., *Pewter of the Channel Islands,* Bartholomew 1973.

OTHER PLACES TO SEE PEWTER

1. Arlington Court, Arlington, Barnstaple, Devon, EX31 4CP. Telephone: 01271 850296 (National Trust).
2. Bewdley Museum, The Shambles, Load Street, Bewdley, Worcestershire, DY12 2AE. Telephone: 01299 403573.
3. Colonial Williamsburg Foundation, P.O. Box C, Williamsburg, Virginia, 23187, U.S.A.
4. Coughton Court, Coughton, Alcester, Warwickshire, B49 5JA. Telephone: 01789 400777.
5. Fitzwilliam Museum, Trumpington Street, Cambridge, CB2 1RB. Telephone: 01223 332900.
6. The Fleece Inn, Bretforton, Near Evesham, Worcestershire. (National Trust). Telephone: 01386 831173.
7. Glasgow Art Gallery and Museum, Kelvingrove, Glasgow G3 8AG. Telephone: 0141 287 2000.
8. Museum of Antiquities, Queen Street, Edinburgh EH2 1JD. Telephone: 0131 225 7534.
9. Museum of British Pewter, Harvard House, High Street, Stratford-upon-Avon, Warwickshire, CV37 6AU. Telephone: 01789 204507 or 204016.
10. Museum of London, London Wall, London, EC2Y 5HN. Telephone: 0171 600 3699.
11. The Royal Museum of Scotland, Chambers Street, Edinburgh, EH1 1JF. Telephone: 0131 225 7534.
12. The Shakespeare Birthplace Trust houses, Stratford-upon-Avon. Telephone: 01789 204016.
13. Sheffield City Museum, Weston Park, Sheffield, South Yorkshire, S10 2TP. Telephone: 01742 768588.
14. Victoria and Albert Museum, Cromwell Road, South Kensington, London, SW7 2RL. Telephone: 0171 938 8500.
15. The Worshipful Company of Pewterers, Pewterers' Hall, Oat Lane, London EC2V 7DE. Telephone: 0171 606 9363. (By appointment only).

GLOSSARY

Apprentice A young man or woman trained by a master craftsman, usually for seven years.

Booge The curved area between the base and rim of a piece of flatware.

Britannia Metal An alloy of tin, antimony and copper, often formed into shape by spinning.

Cartouche An extra stamp, sometimes applied by pewterers, including a statement of quality or an address, surrounded by a decorative border.

Charger An item of flatware over 18 inches in diameter.

Chopin A Scottish measure of one and a half English pints.

Dish An item of flatware between 12 and 18 inches in diameter.

Flagon A lidded vessel for serving drinks, usually larger than a measure.

Flatware Saucers, plates, dishes, chargers, basins and bowls.

Garnish A set of flatware for the table, usually a dozen of each item.

Gill A quarter of a pint.

Hallmarks A set of four marks similar to those on silver and gold, individual to each pewterer but not including a date letter or quality information.

Hammermen Metal-workers who used a hammer as a main tool.

Hollow-ware Vessels made to contain liquids, as distinct from flatware.

Journeyman A trained craftsman working for a master.

Label Similar to 'cartouche' but inside a plain border.

Master A craftsman who has completed an apprenticeship.

Mug An unlidded drinking vessel.

Mutchkin A Scottish measure of three-quarters of an English pint.

Noggin An Irish measure of a quarter of a pint.

Paten A shallow plate used for bread during Holy Communion.

Plate An item of flatware between 7 and 12 inches in diameter.

Porringer A small bowl with either one or two handles or "ears", for eating soft foods such as gruel.

Pot Another word for a mug or, in the Channel Isles, a flagon of 72 fluid ounce capacity.

Quaich A uniquely Scottish bowl, similar to a porringer, extremely rare in pewter and probably made by itinerant tinkers.

Reeding Decoration of circular lines, either cast or incised, often found on the rims of flatware.

Repoussé Relief decoration formed by hammering.

Sadware Another word for flatware.

Saucer An item of flatware less than 7 inches in diameter.

Scots pint Equivalent to three English pints.

Searcher A pewterer instructed to examine pewter for sale, or being made, for quality.

Tankard A lidded drinking vesel.

Thumbpiece A lever to assist raising the lid of a flagon or tankard.

Touchmark Maker's mark applied to pewterwares.

Trencher Another word for plate.

Verification marks Marks applied to measures in pewter and other materials by inspectors, to show that the measure contained the correct amount.

Wrigglework "Zig-zag" engraving made by "walking" a screwdriver-like tool from corner to corner.